Doodle a Poodle

LARK
New York

LARK
New York

An Imprint of Sterling Publishing
1166 Avenue of the Americas
New York, NY 10036

First published in Great Britian in 2016 by LOM ART, an imprint of
Michael O'Mara Books Limited, 9 Lion Yard, Tremadoc Road, London SW4 7NQ

ISBN 978-1-4547-0983-1

Distributed in Canada by Sterling Publishing
c/o Canadian Manda Group, 664 Annette Street
Toronto, Ontario, Canada M6S 2C8

For information about custom editions, special sales, and premium and corporate purchases,
please contact Sterling Special Sales at 800-805-5489 or specialsales@sterlingpublishing.com.

Cover design by John Bigwood

Manufactured in China

2 4 6 8 10 9 7 5 3 1

larkcrafts.com

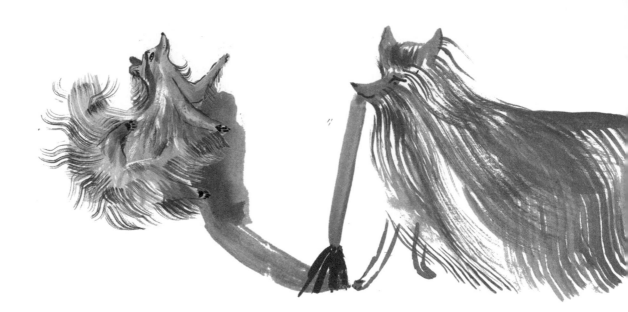

This is not just a coloring book. It's an inspiration book that invites you to color, copy, doodle, and draw thirty cute canines.

Why not experiment with new media, lines, and techniques? There are some suggestions at the beginning of the book that illustrate different ways to approach sketching and making marks.

From Bulldogs to Bassett Hounds, Shih Tzus to Shar Peis, the quirky illustrations in this book show a selection of different dog breeds and reflect their particular personalities.

Go on ... unleash your inner artist.

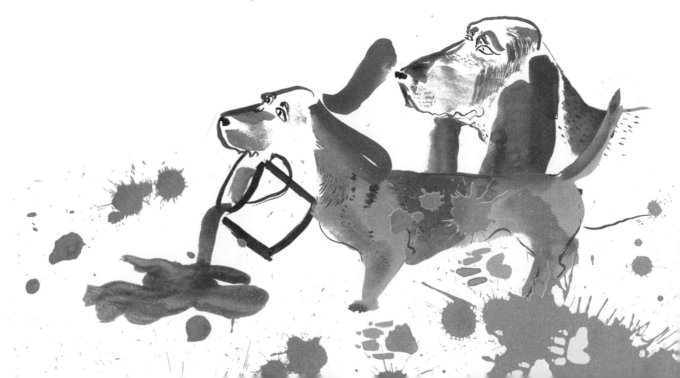

TECHNIQUES

Here are just a few marks you can make and techniques you can use to complete and create pictures in this book.

Use two colors to create wispy fur-like marks.

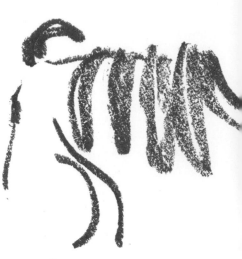

Broken crayon lines add texture.

Use spots of ink for patterned fur.

Mix together pencil and pen to create depth.

Create strong outlines with a black marker pen.

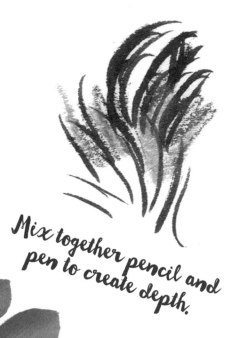

Blobby poster paint can make wrinkles and interesting marks.

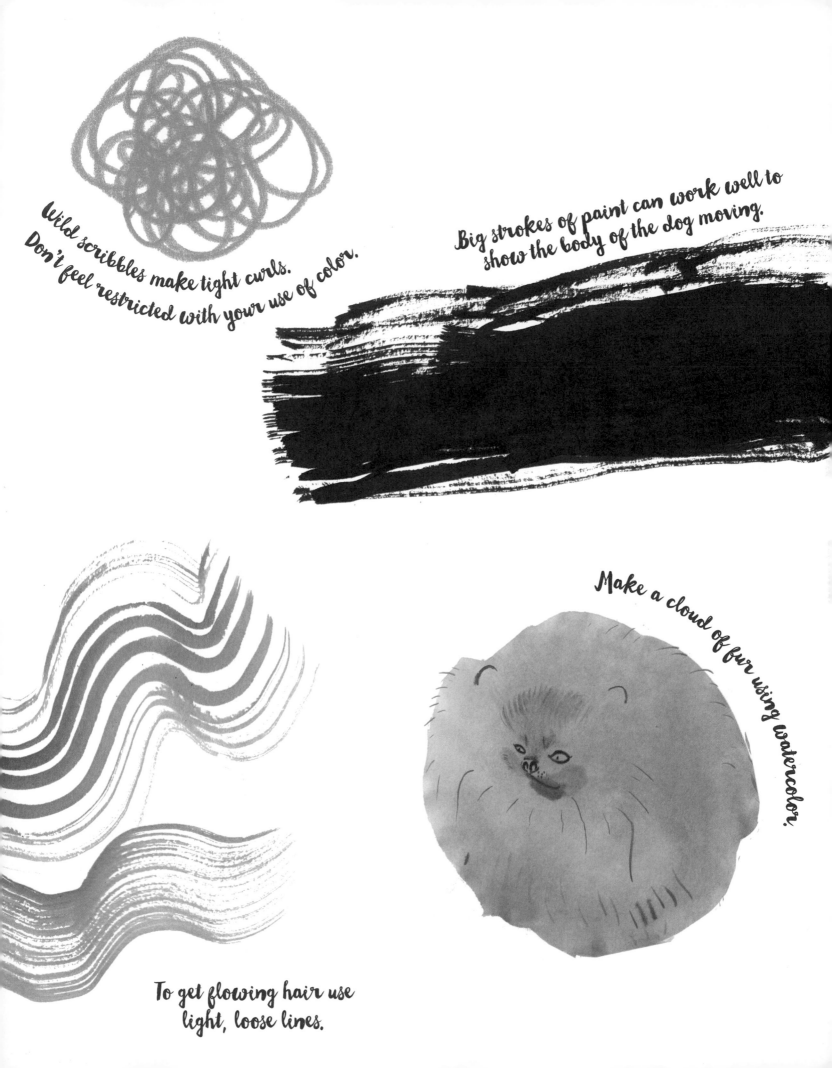

Wild scribbles make tight curls. Don't feel restricted with your use of color.

Big strokes of paint can work well to show the body of the dog moving.

Make a cloud of fur using watercolor.

To get flowing hair use light, loose lines.

AFGHAN HOUND

Flowing lines and elegance.

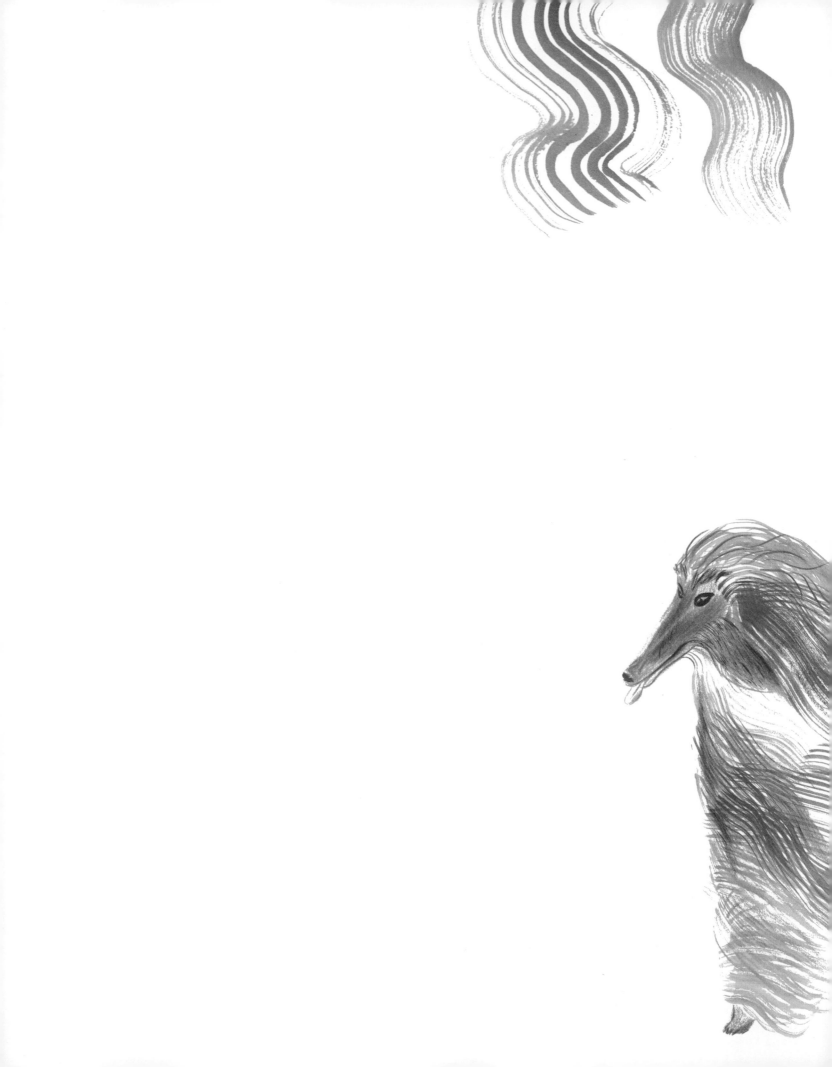

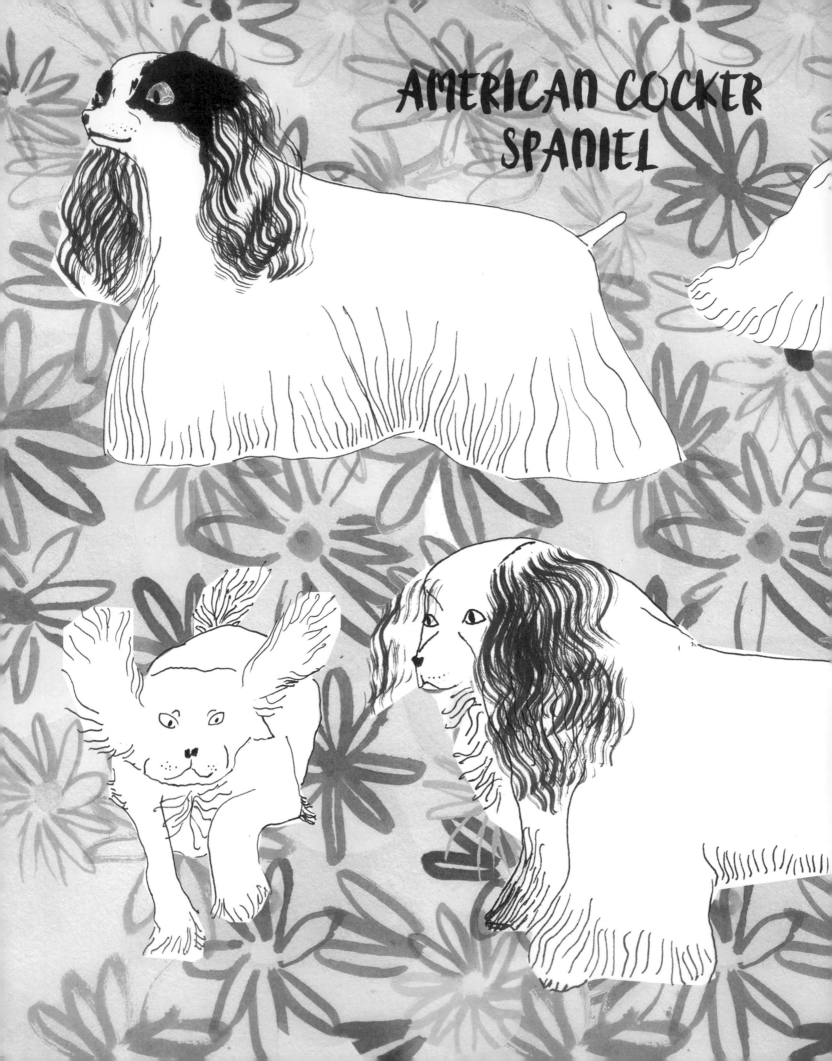

AMERICAN COCKER
SPANIEL

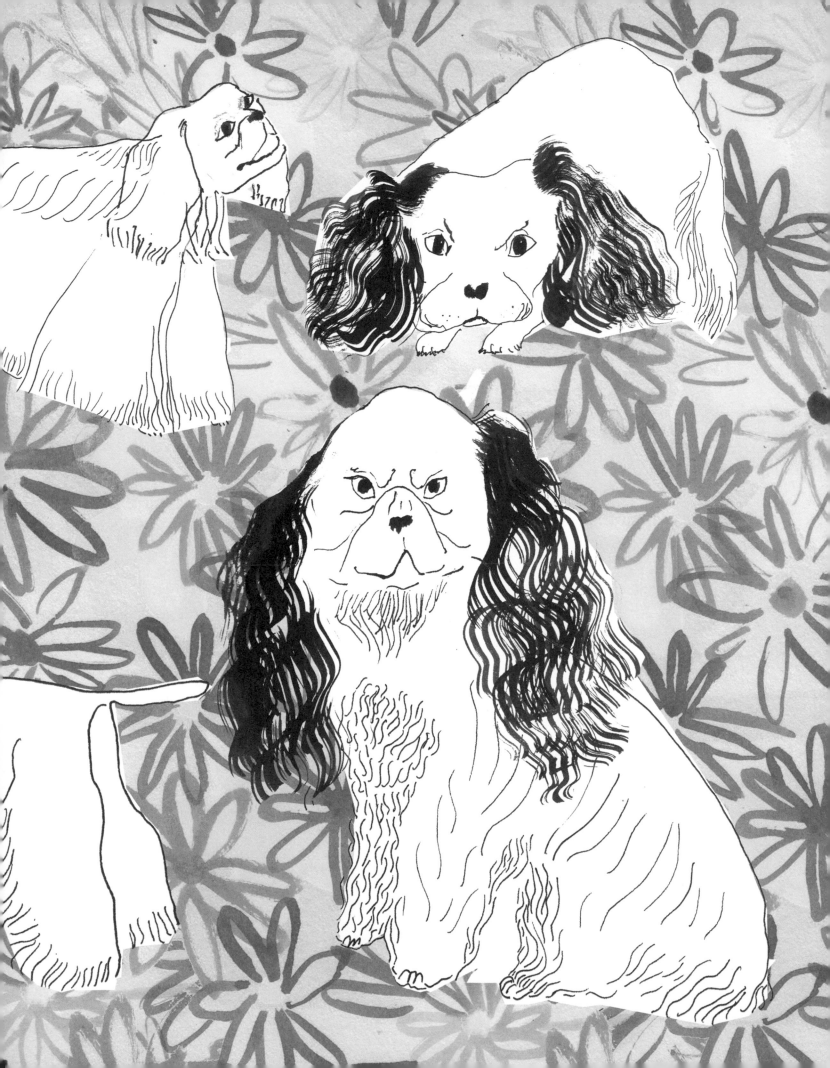

BASSET HOUND

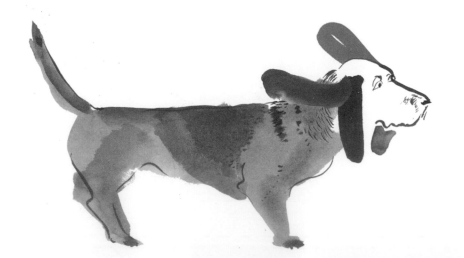

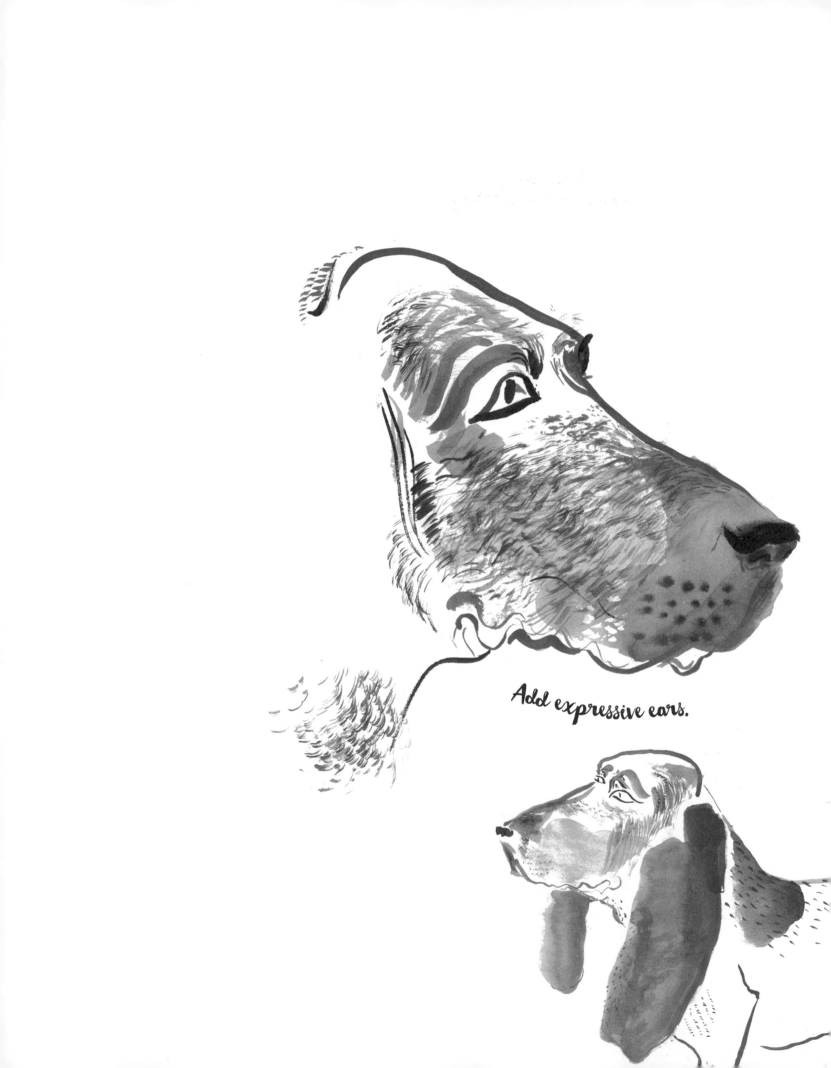

Add expressive ears.

BEAGLE

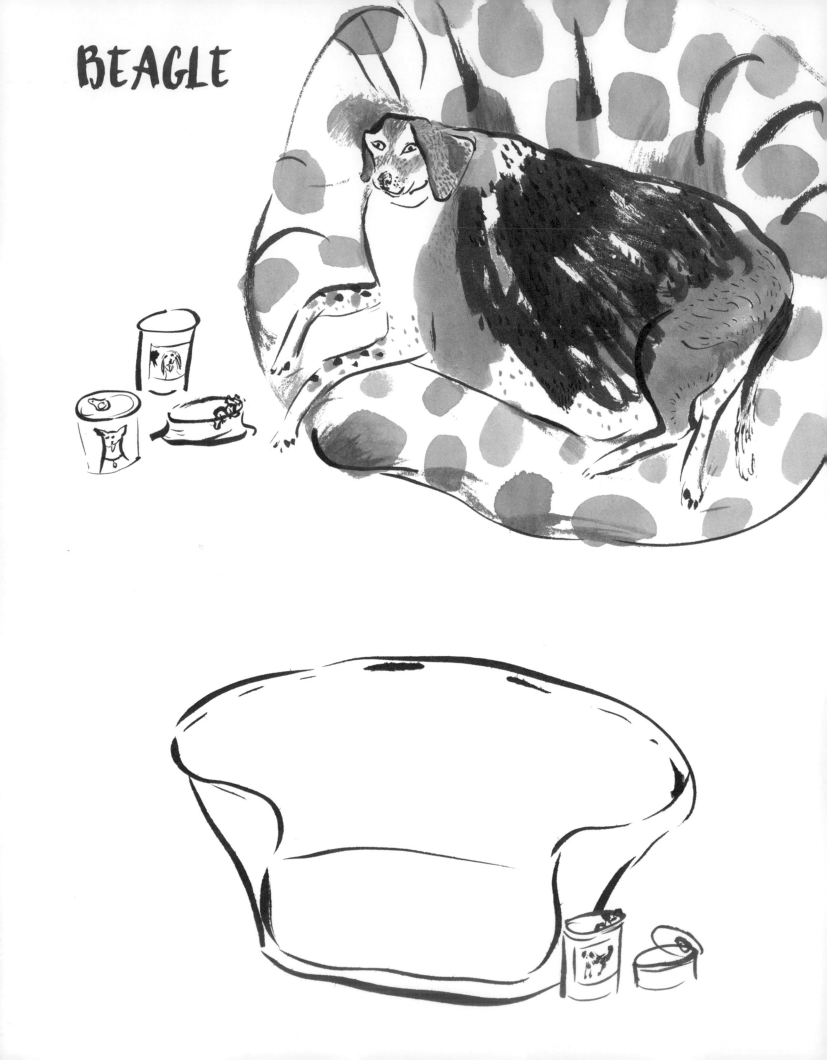

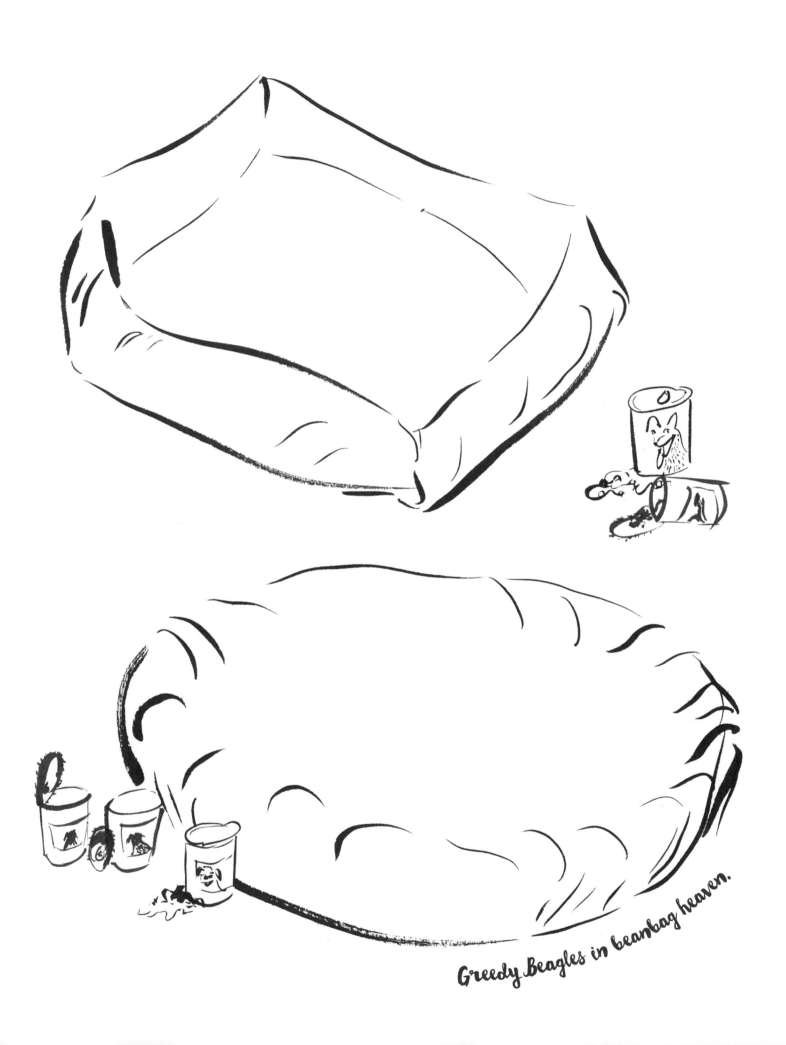

Greedy Beagles in beanbag heaven.

BORDER COLLIE

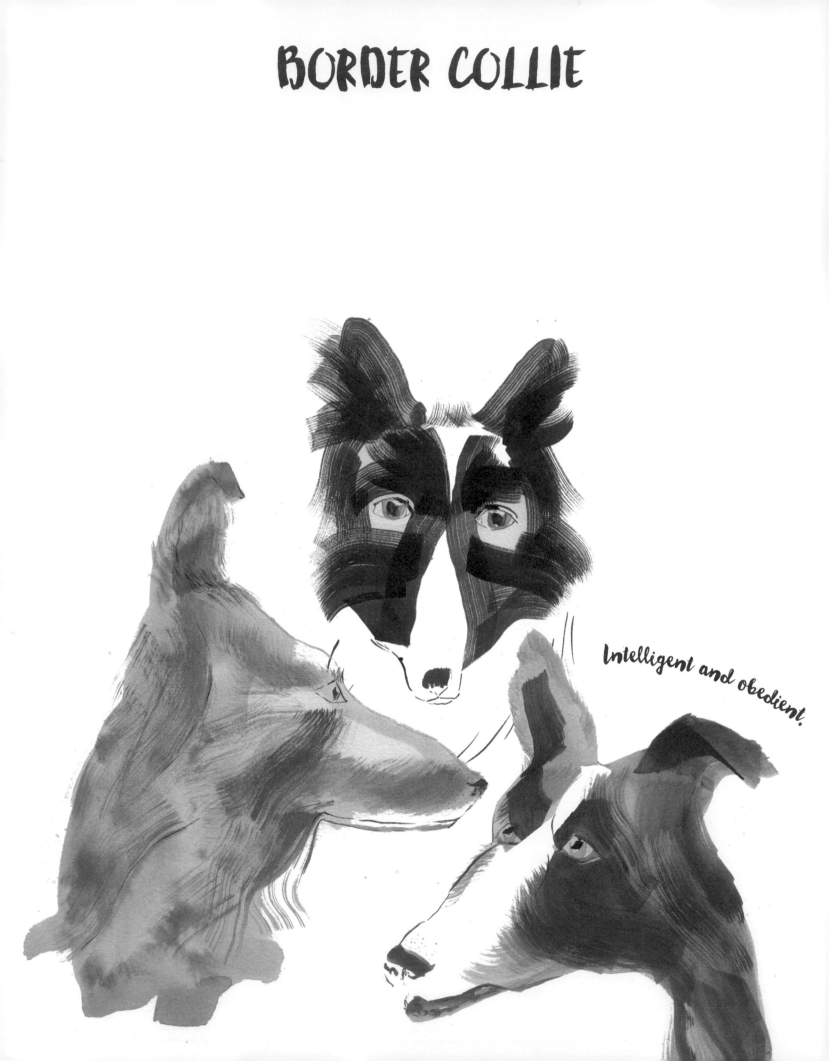

Intelligent and obedient!

BOXER

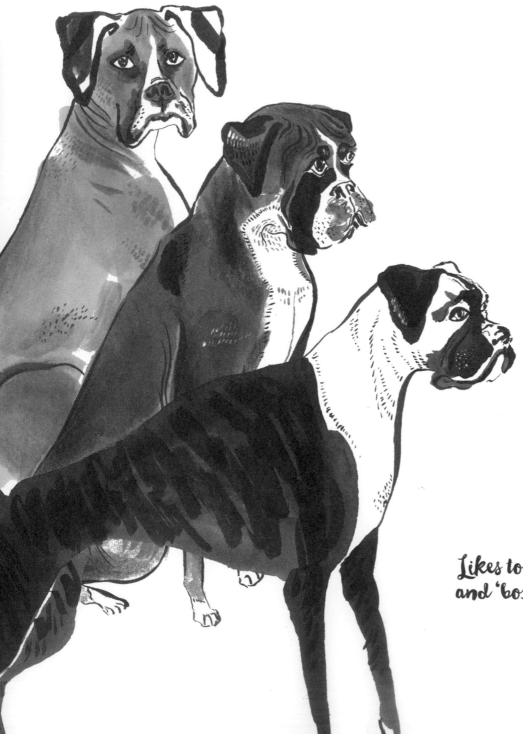

Likes to stand on its hind legs
and 'box' with its front paws.

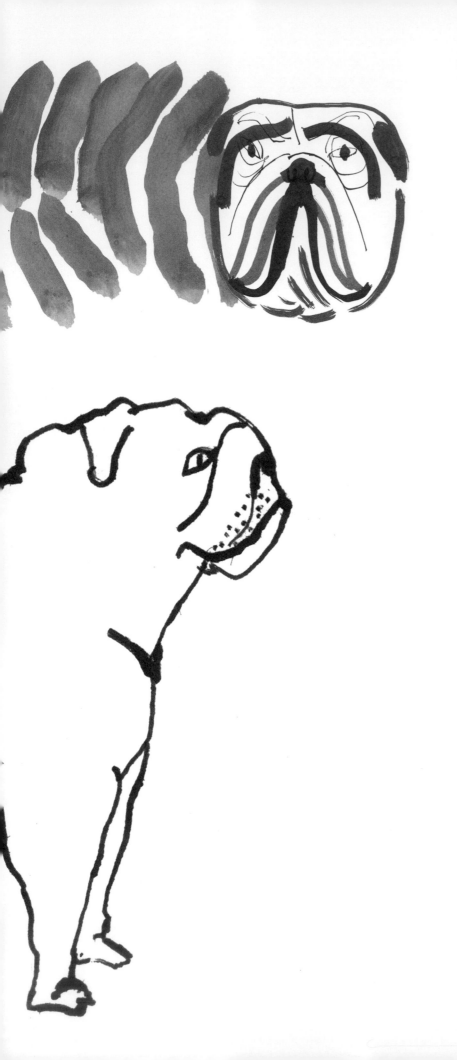

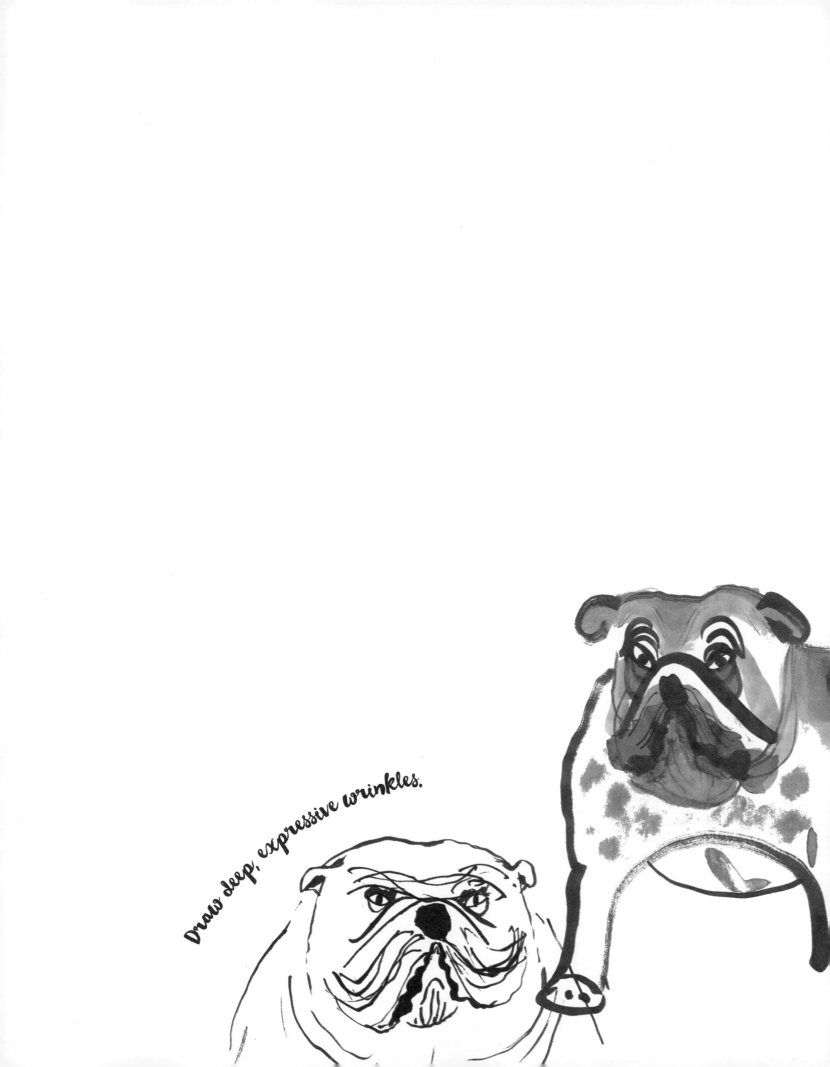

Draw deep, expressive wrinkles.

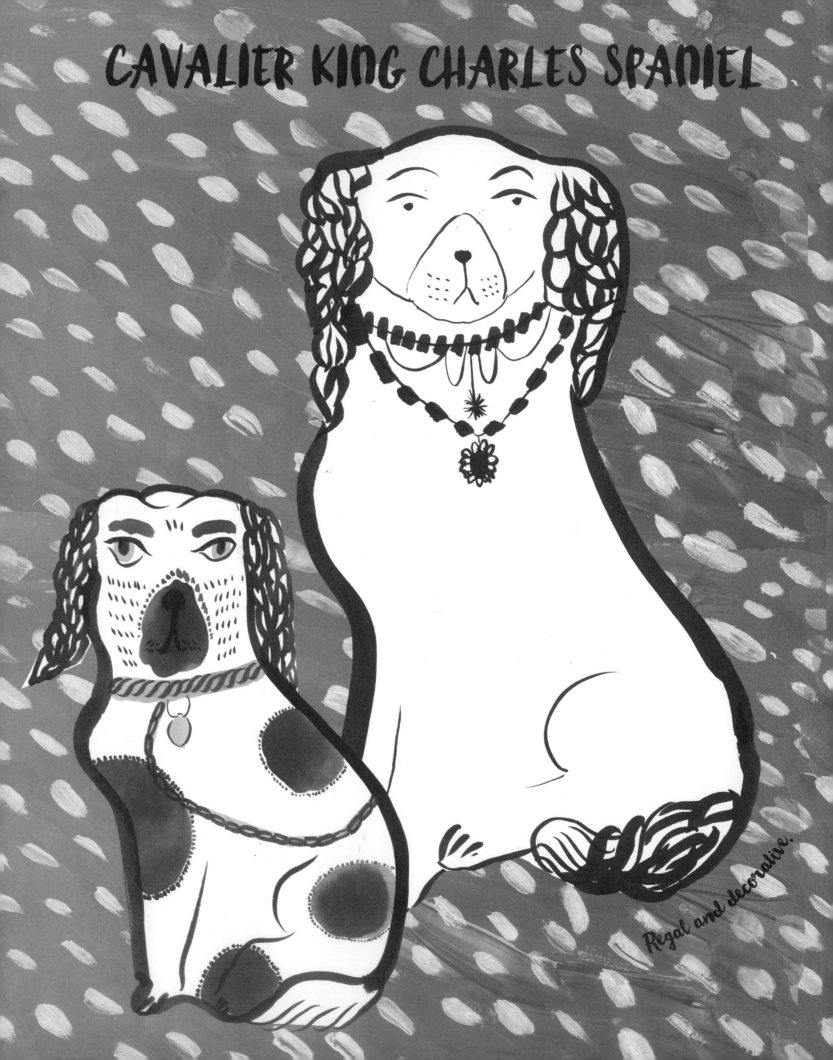

CAVALIER KING CHARLES SPANIEL

Regal and decorative.

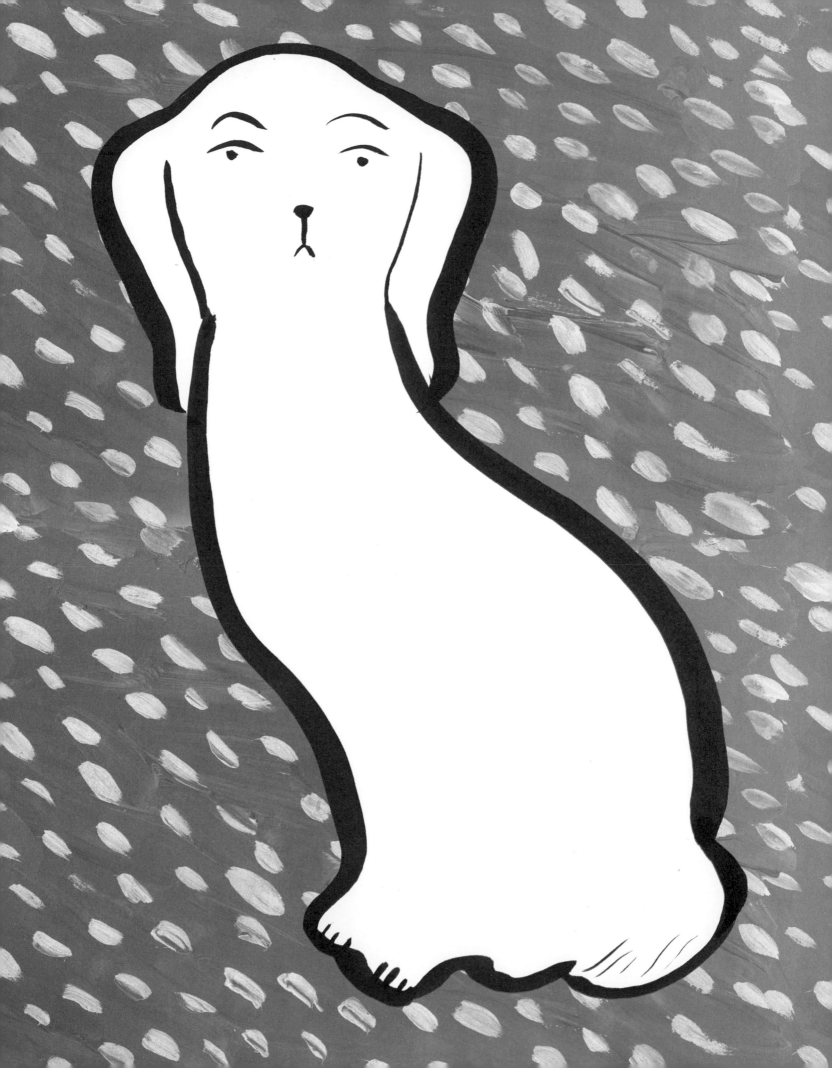

CHIHUAHUA

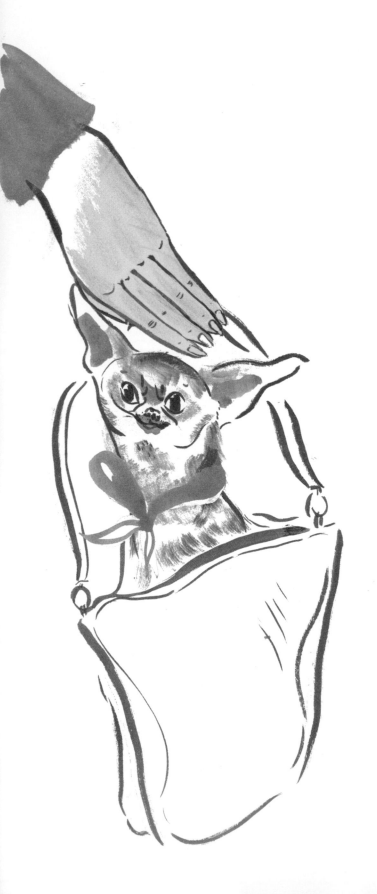

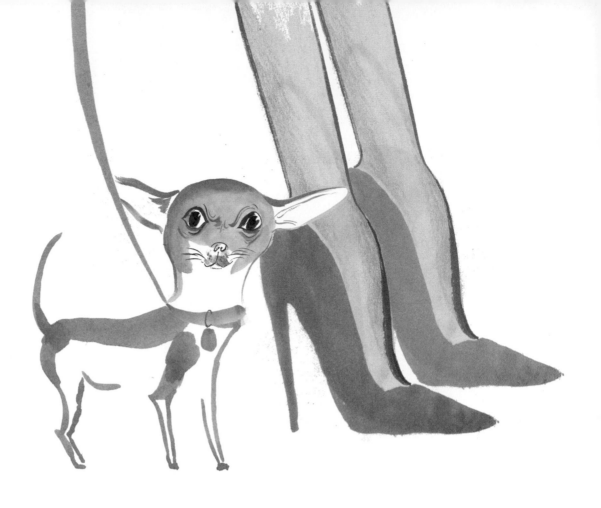

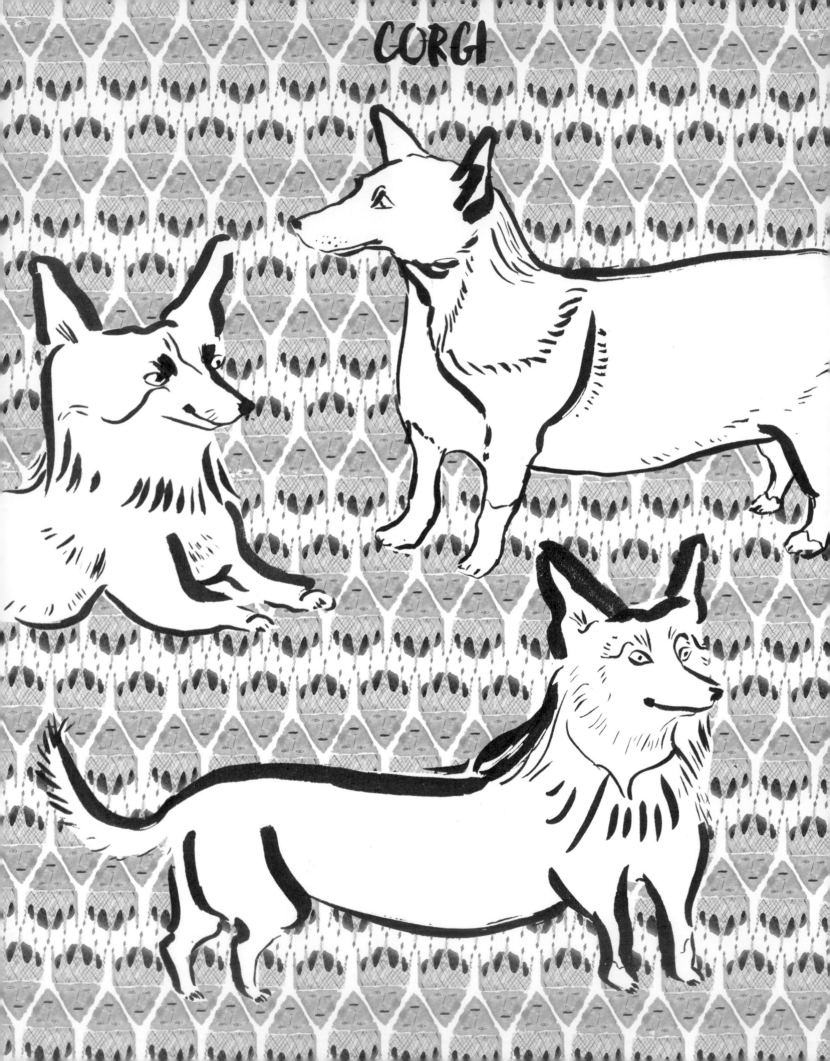

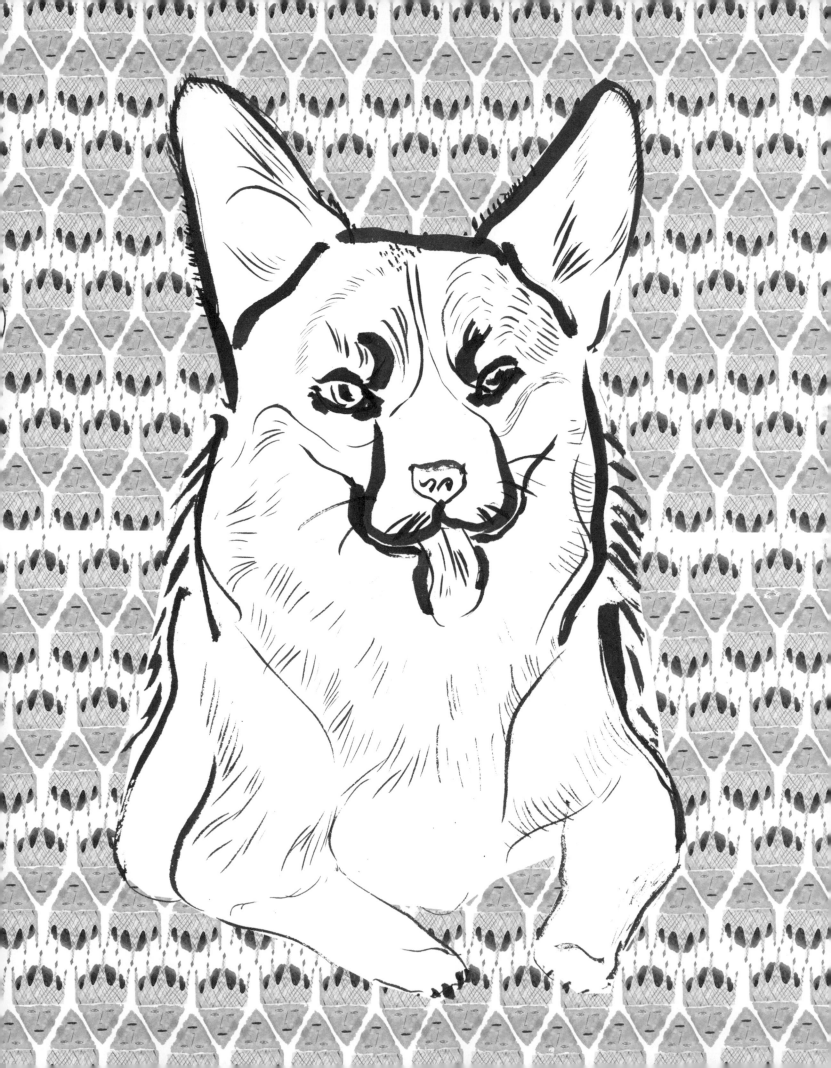

DACHSHUND

One sweeping brush stroke.

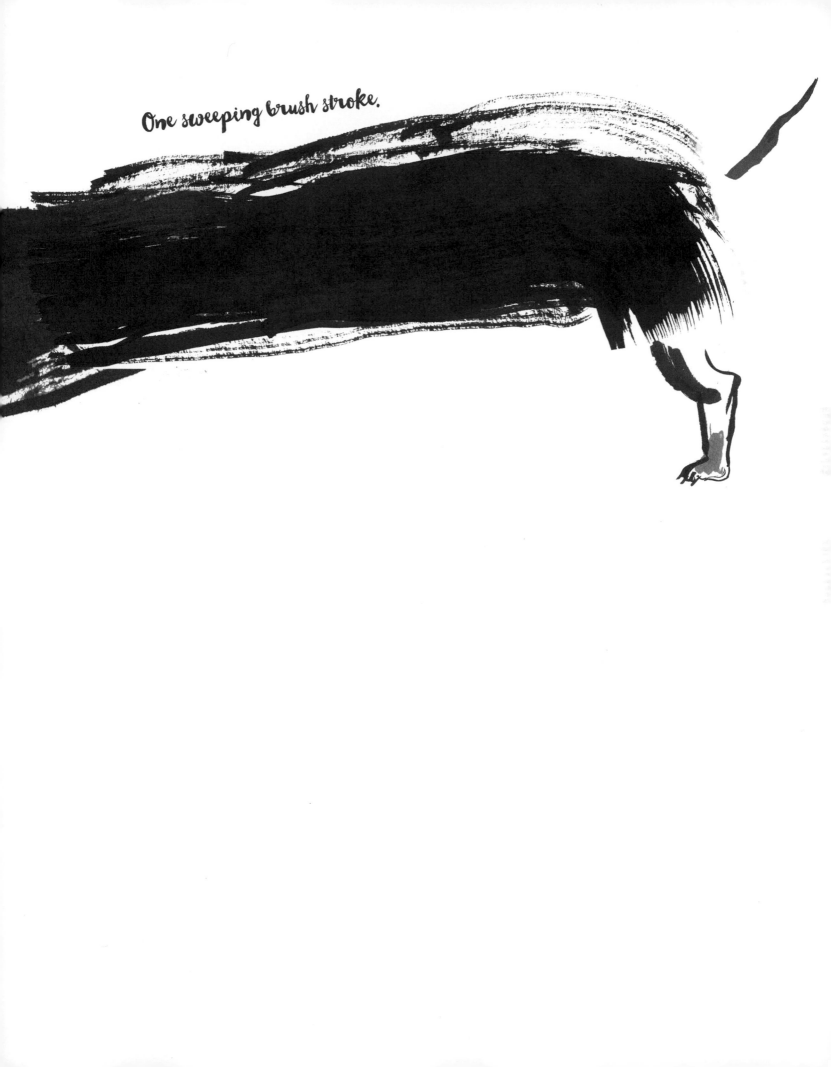

DOBERMAN PINSCHER

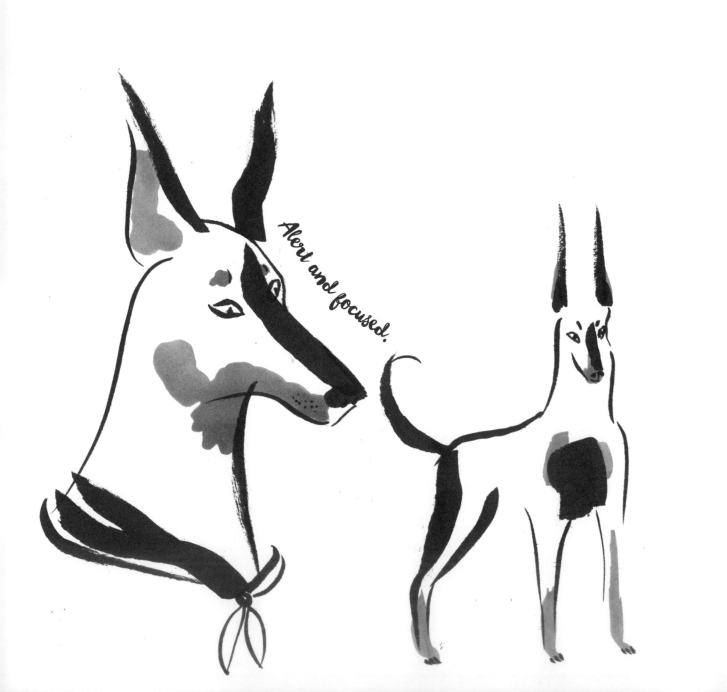

Alert and focused.

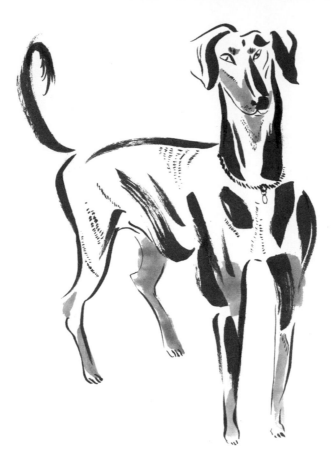

GERMAN SHEPHERD

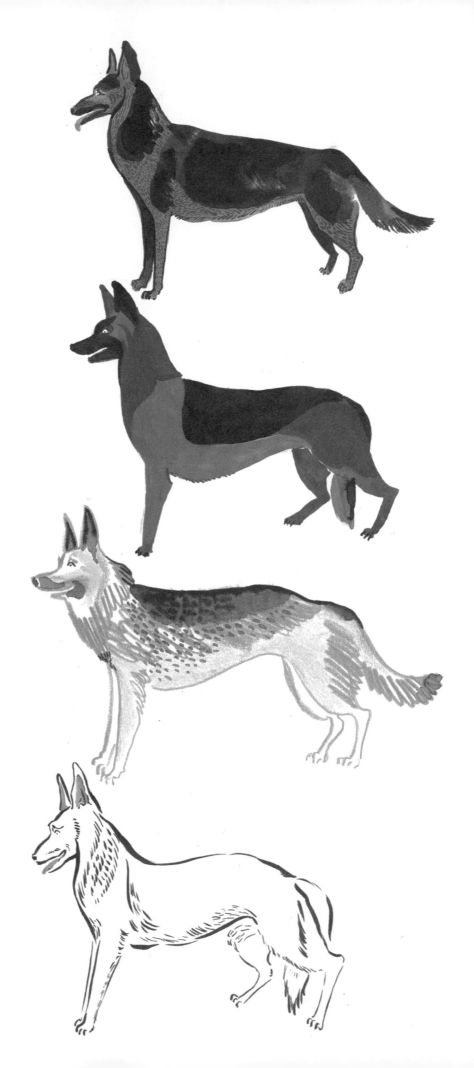

GOLDEN RETRIEVER

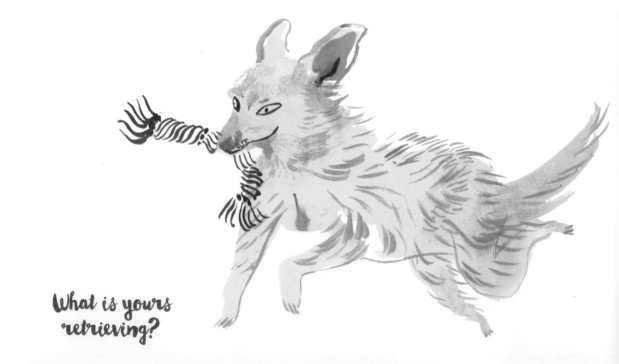

What is yours
retrieving?

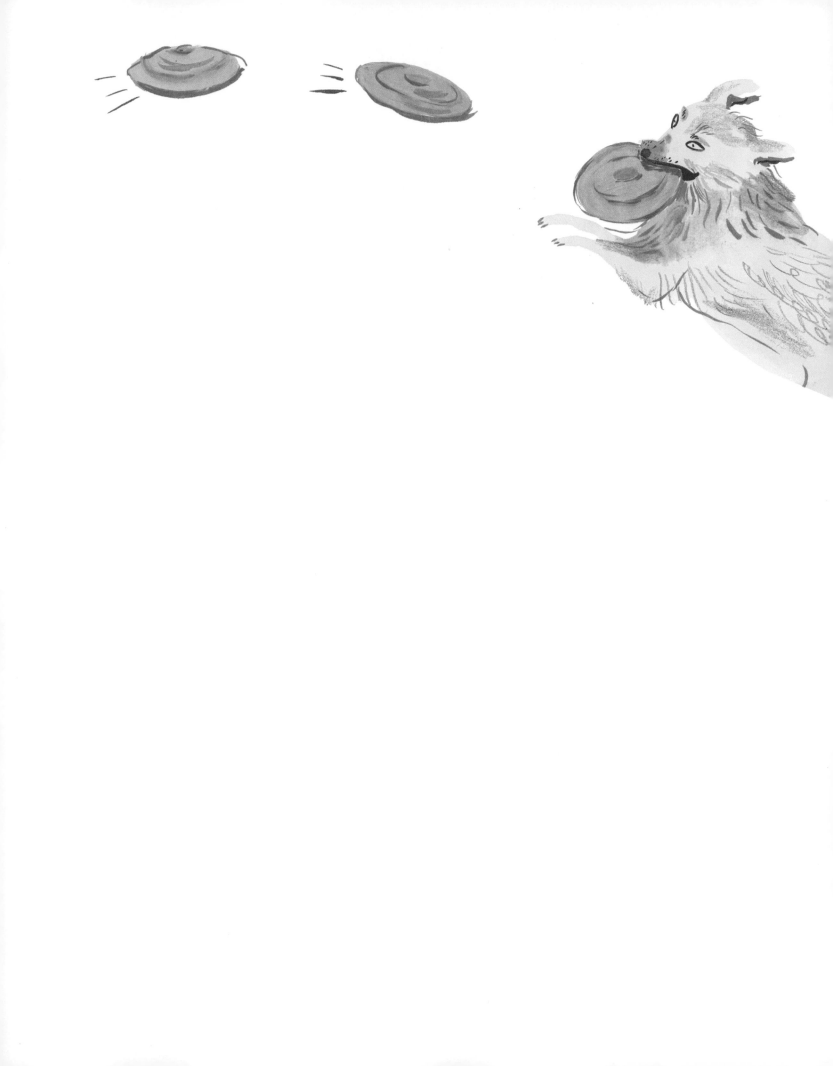

GREAT DANE

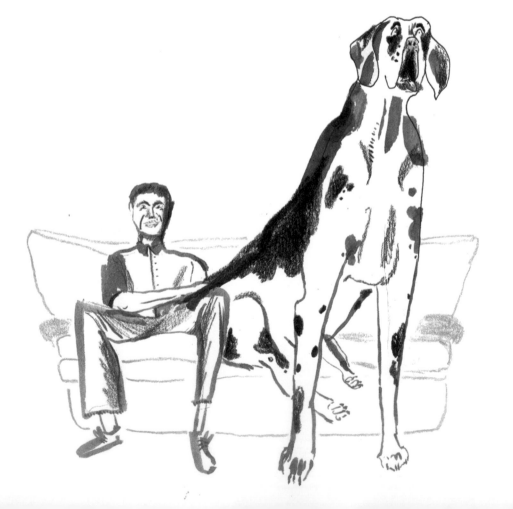

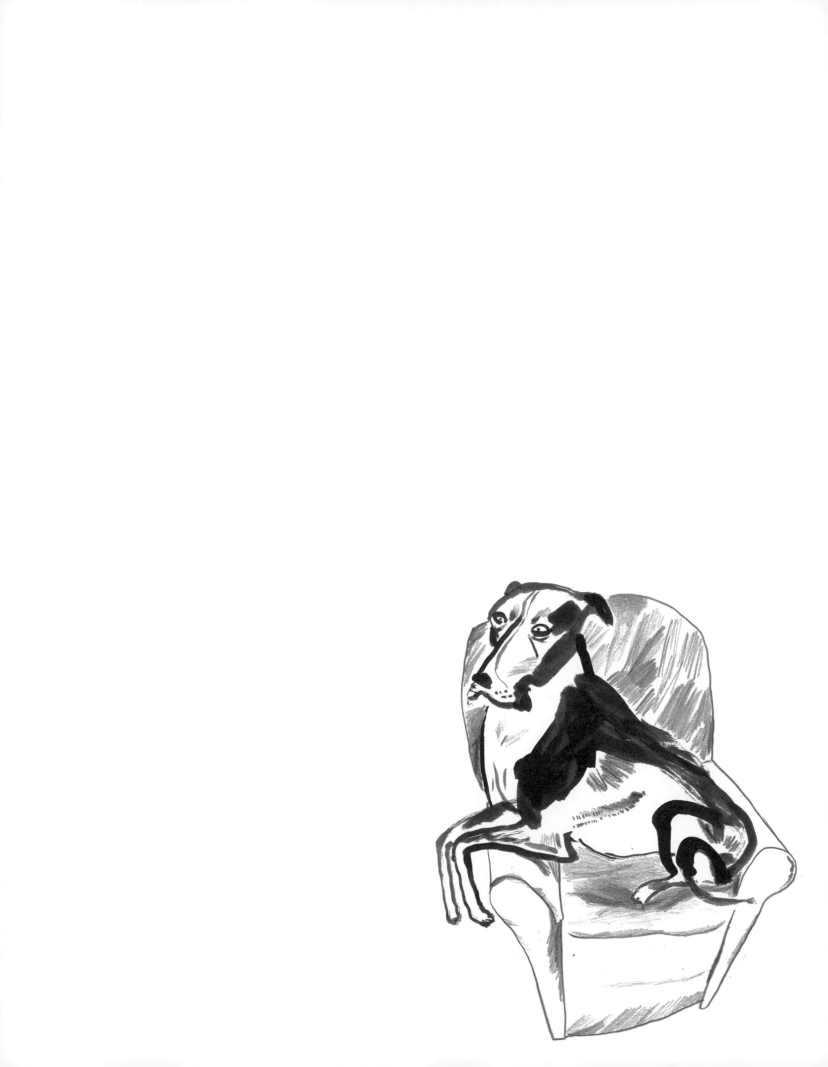

GREYHOUND

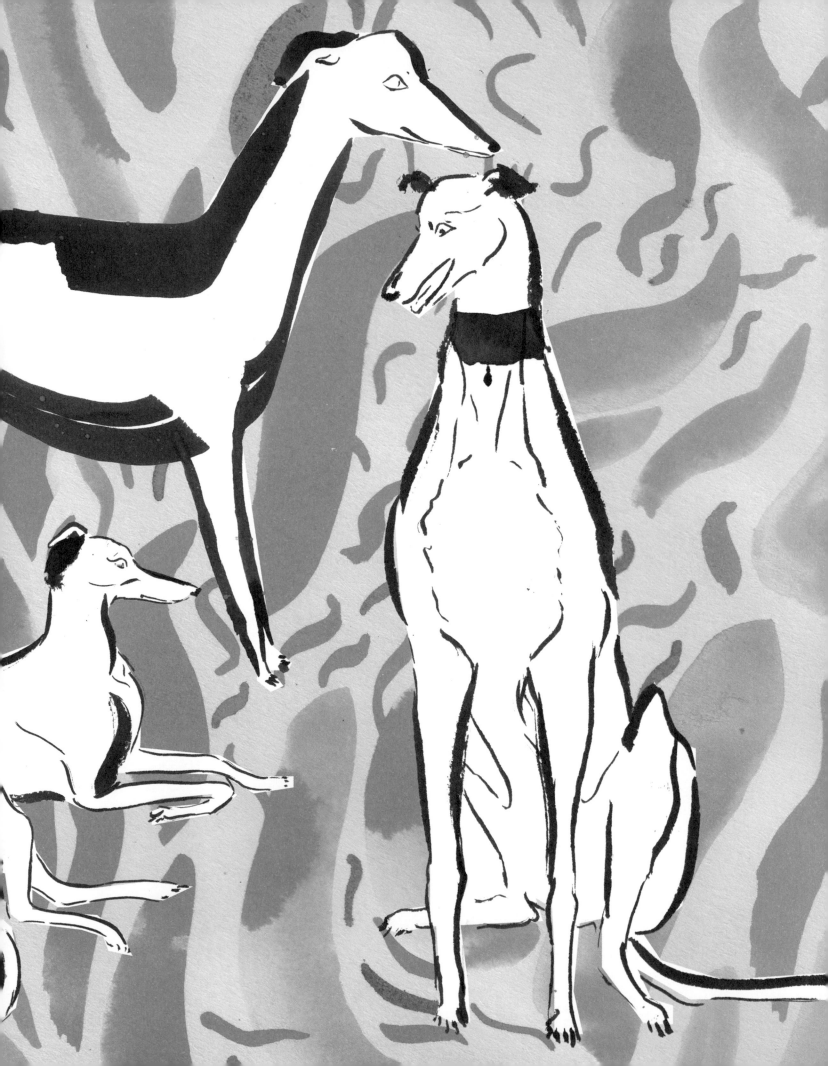

HUSKY

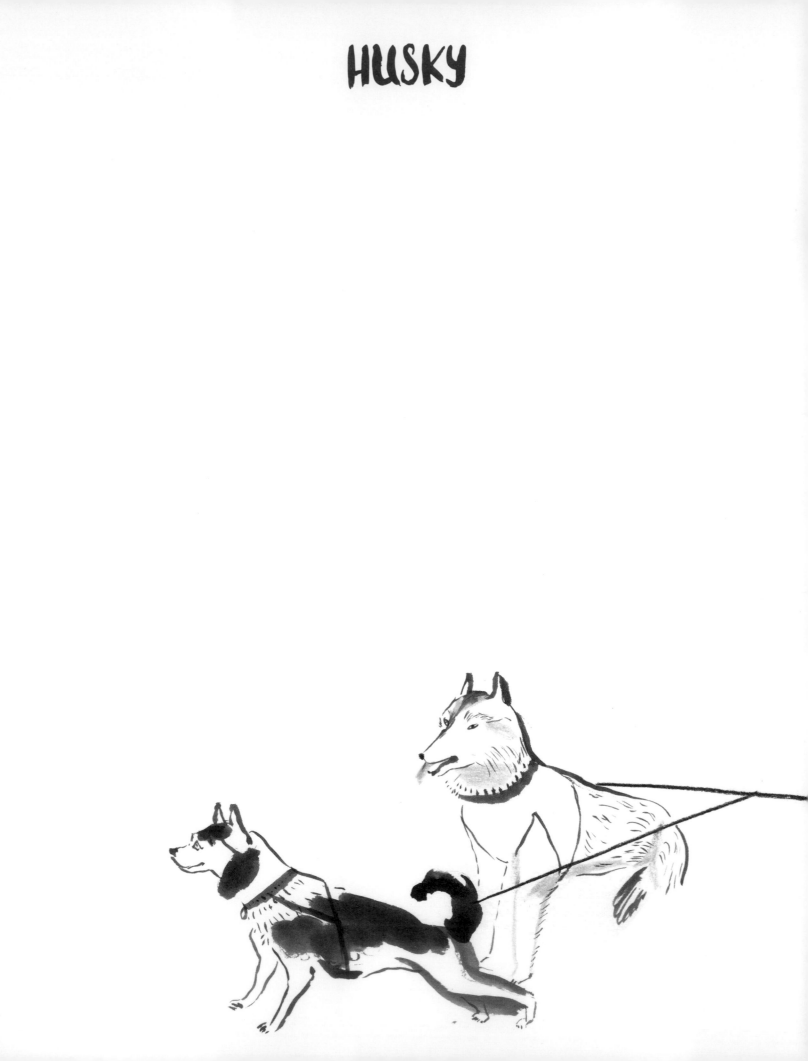

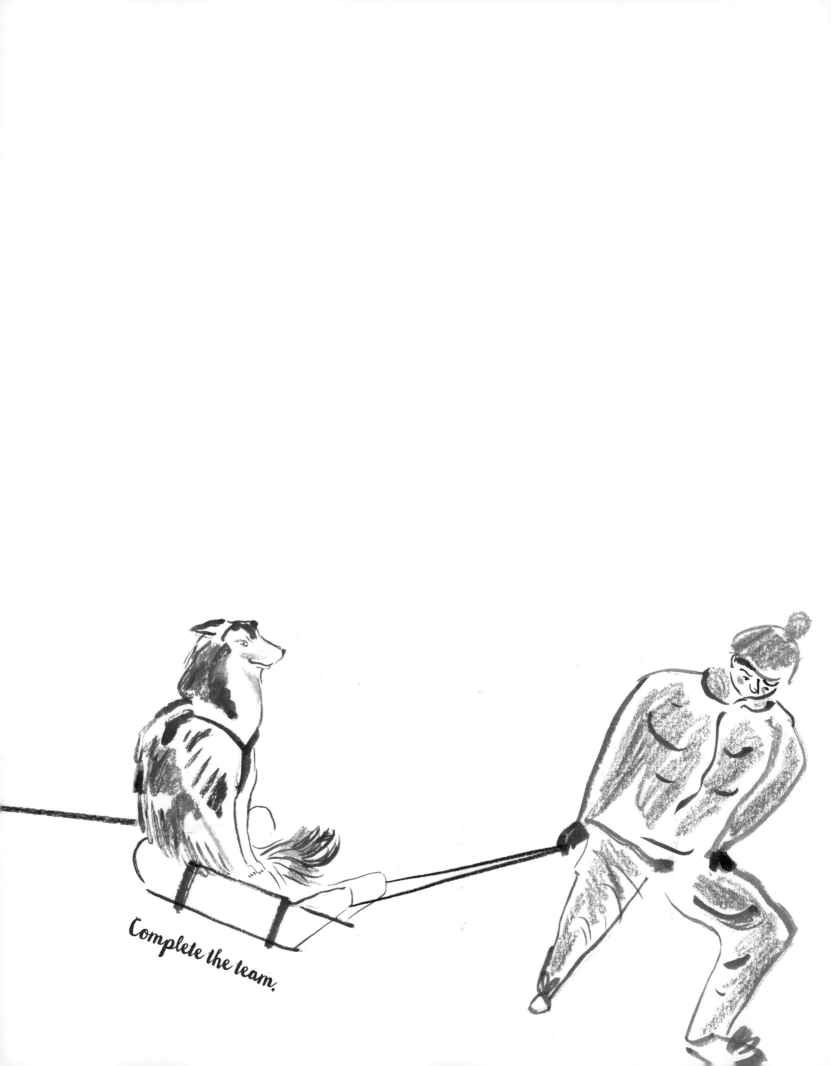

Complete the team.

LABRADOR RETRIEVER

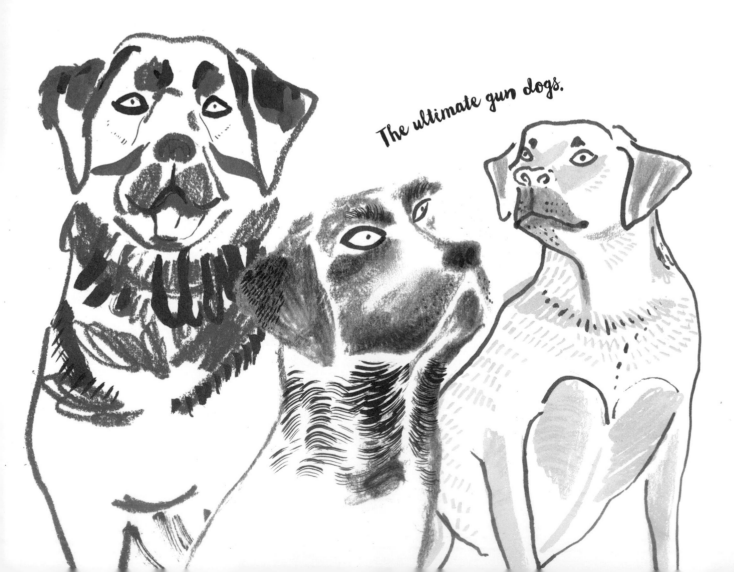

The ultimate gun dogs.

MALTESE

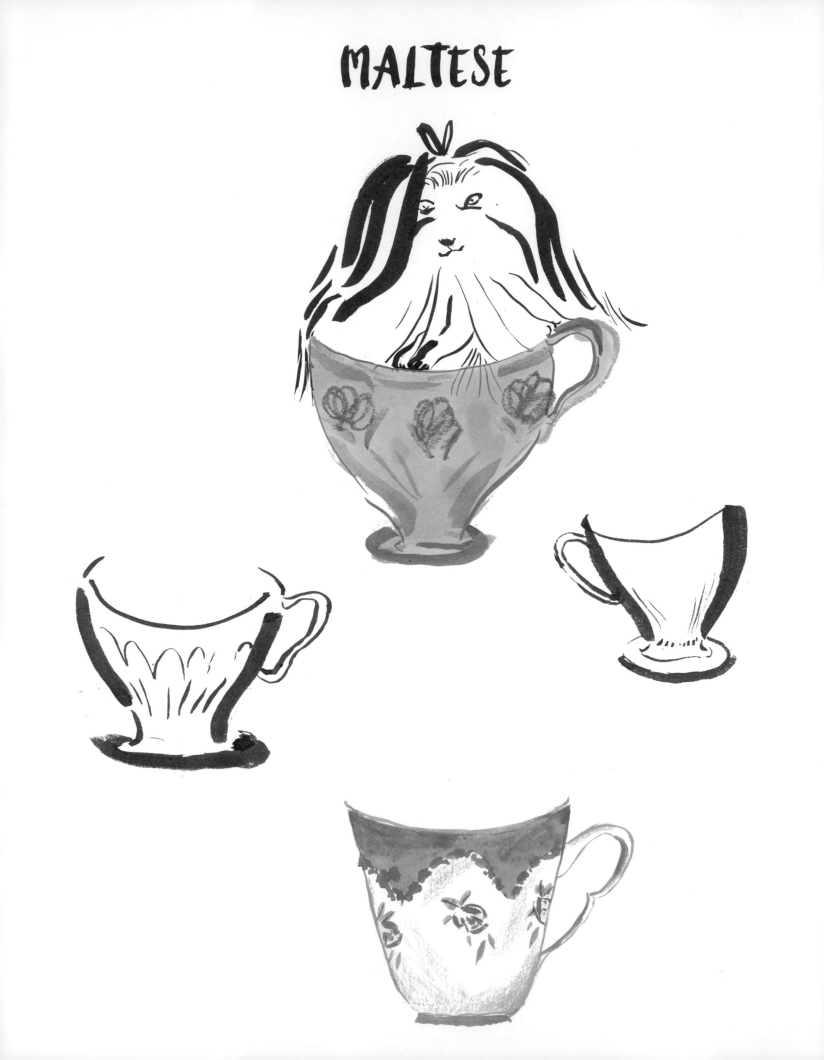

MINIATURE SCHNAUZER

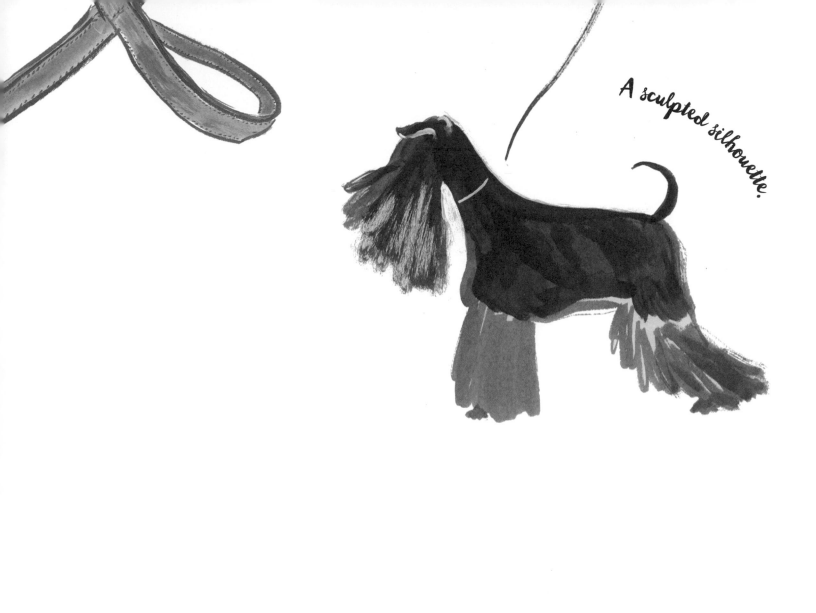

A sculpted silhouette.

POMERANIAN

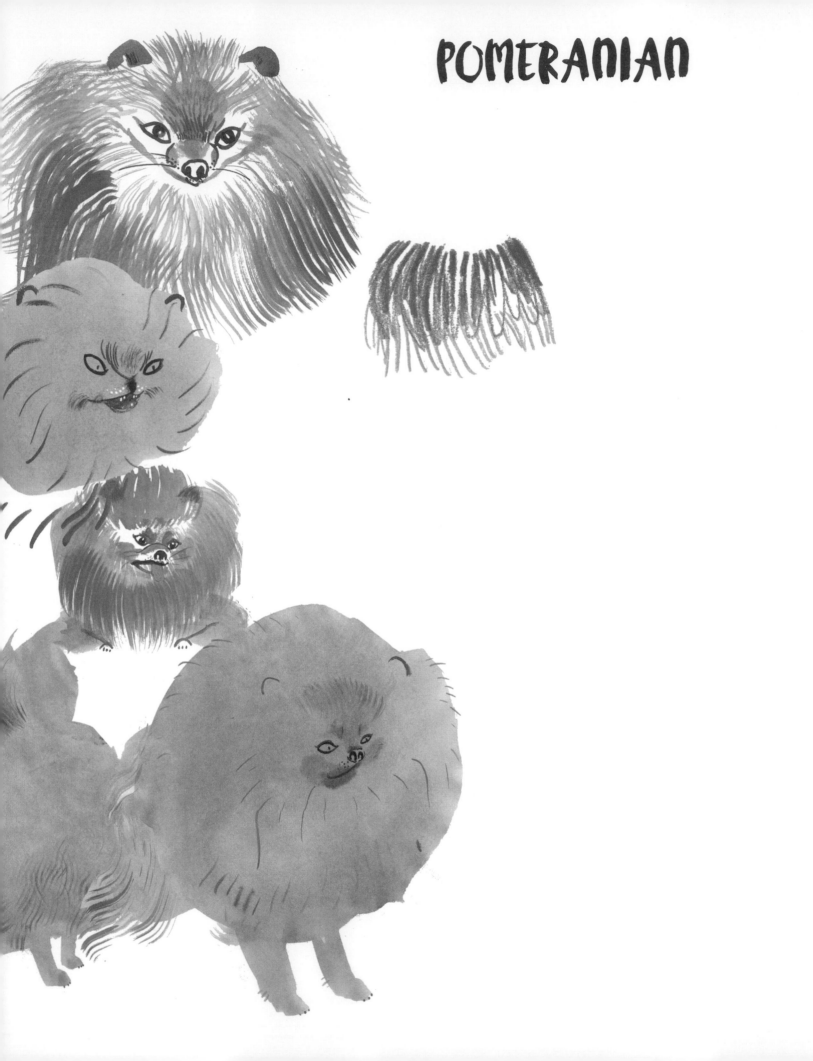

POODLE

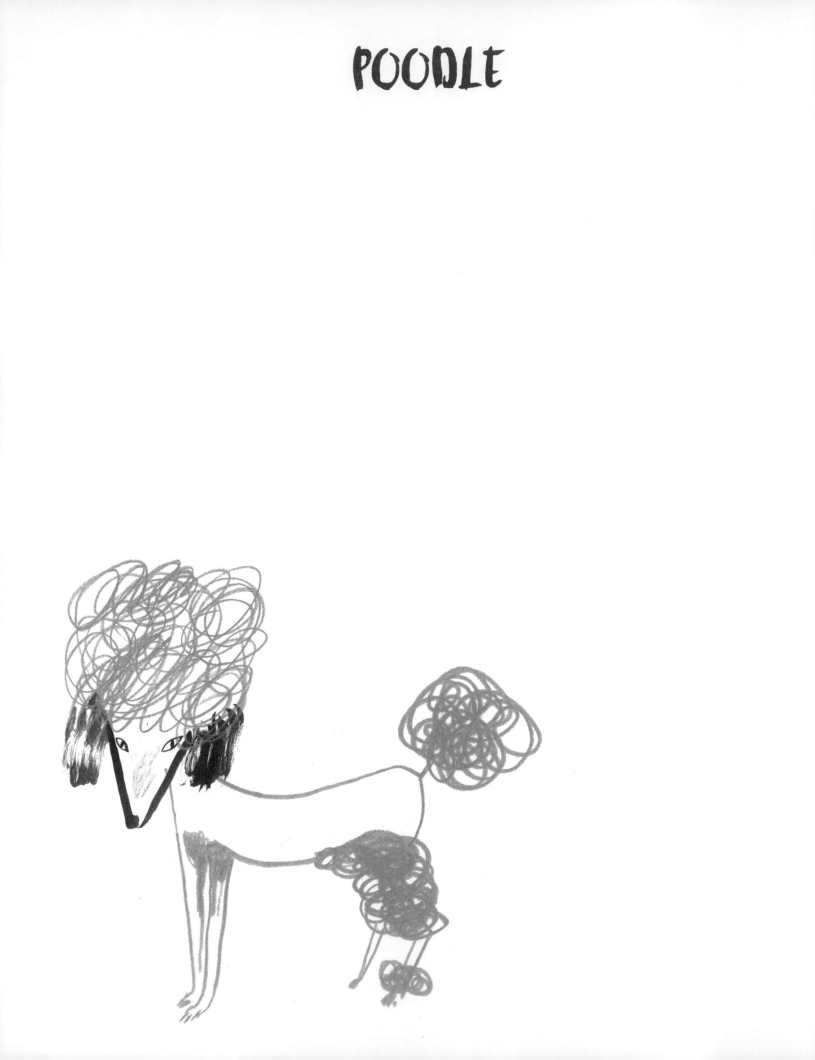

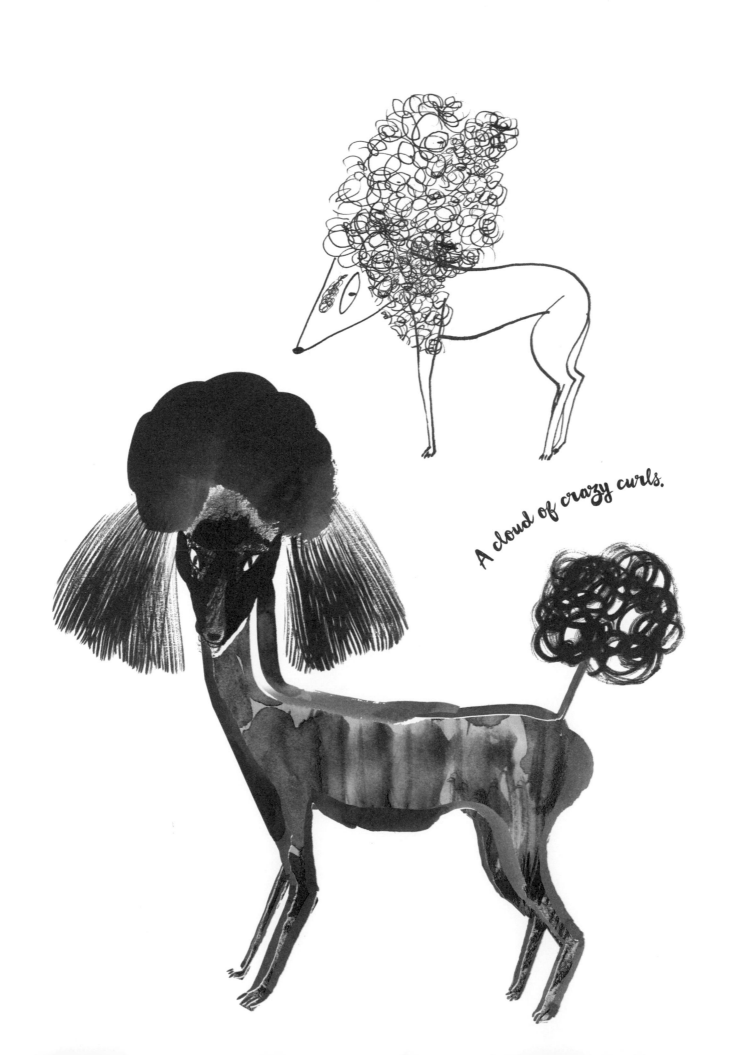

A cloud of crazy curls.

PUG

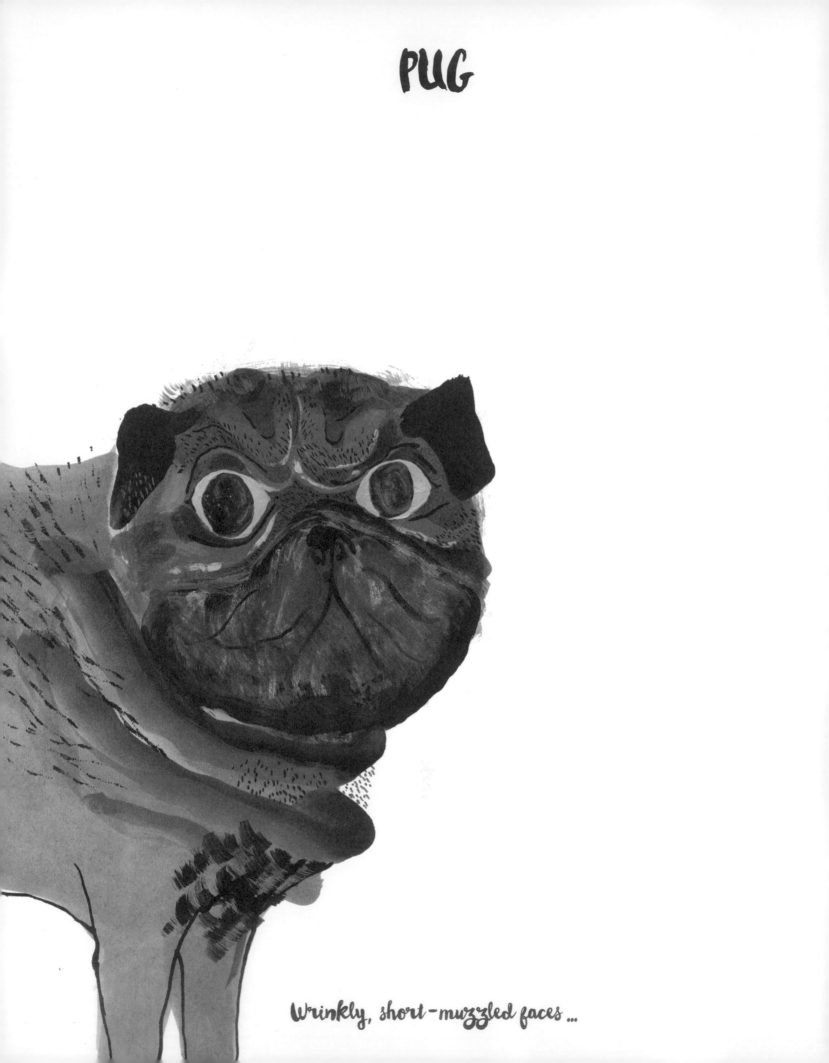

Wrinkly, short-muzzled faces ...

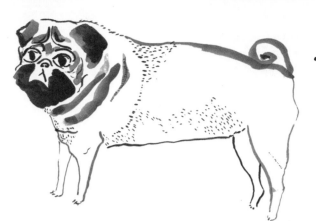

... and don't forget a curly tail.

ROTTWEILER

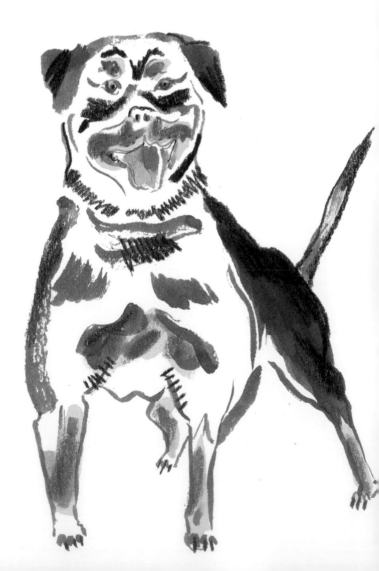

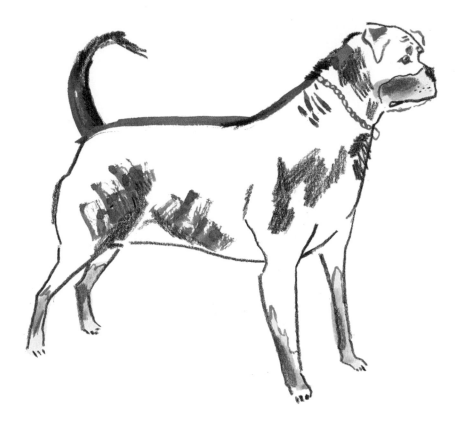

ROUGH COLLIE

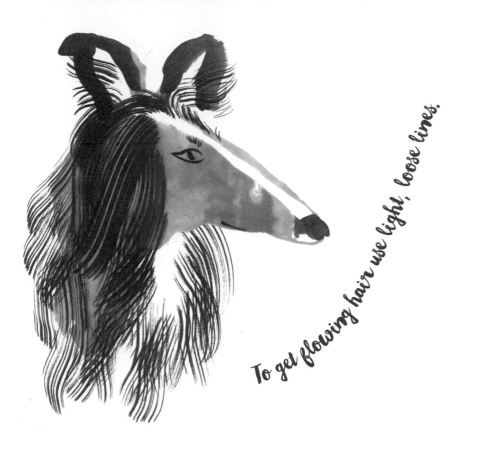

To get flowing hair use light, loose lines.

SHAR PEI

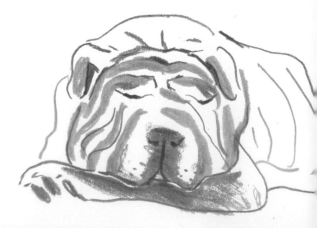

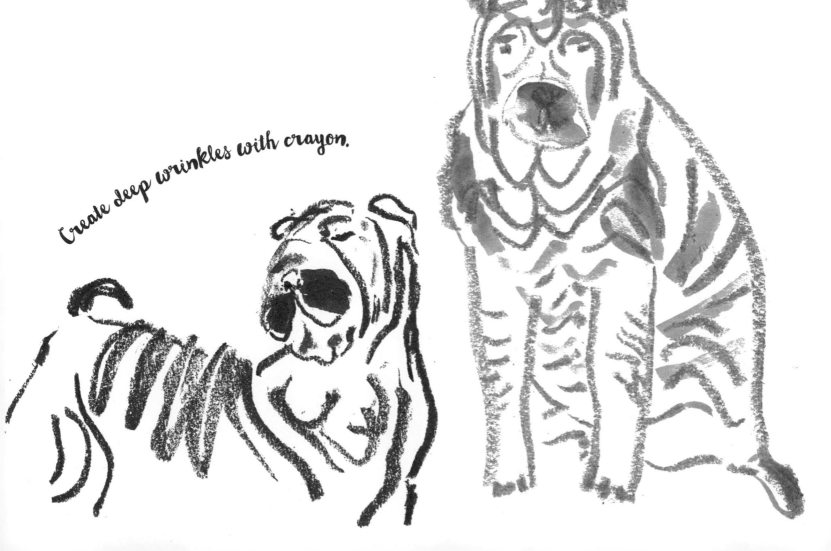

Create deep wrinkles with crayon.

SHIH TZU

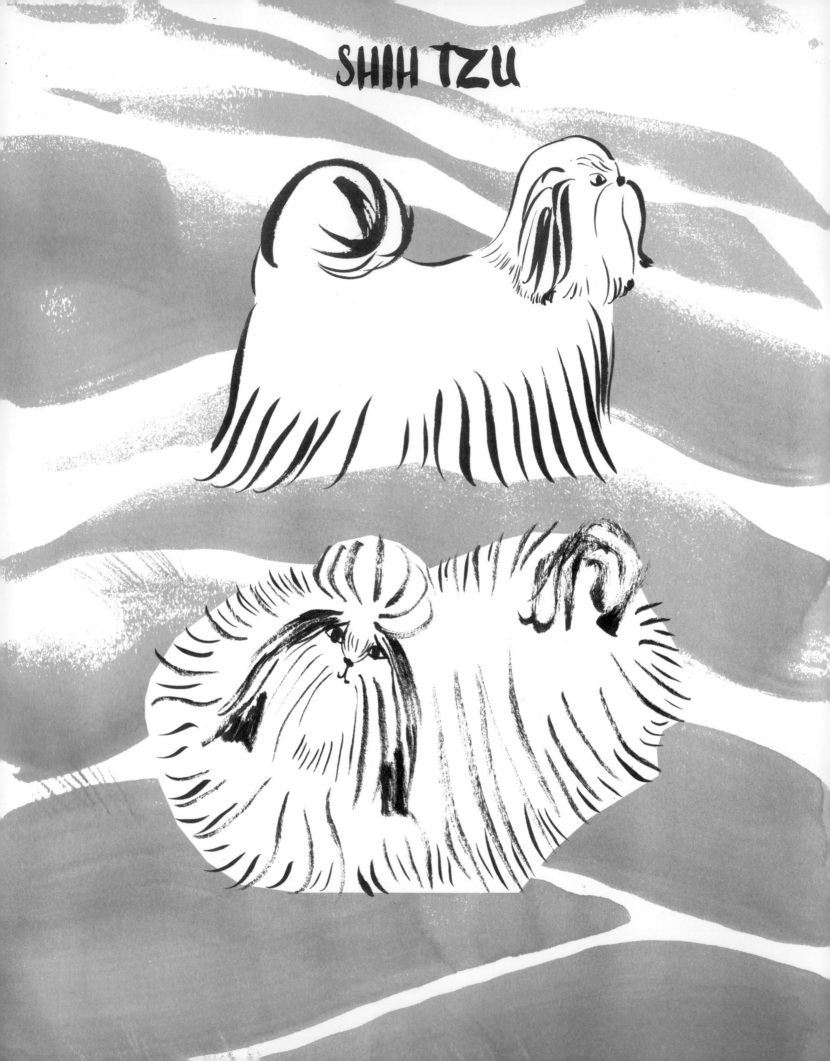

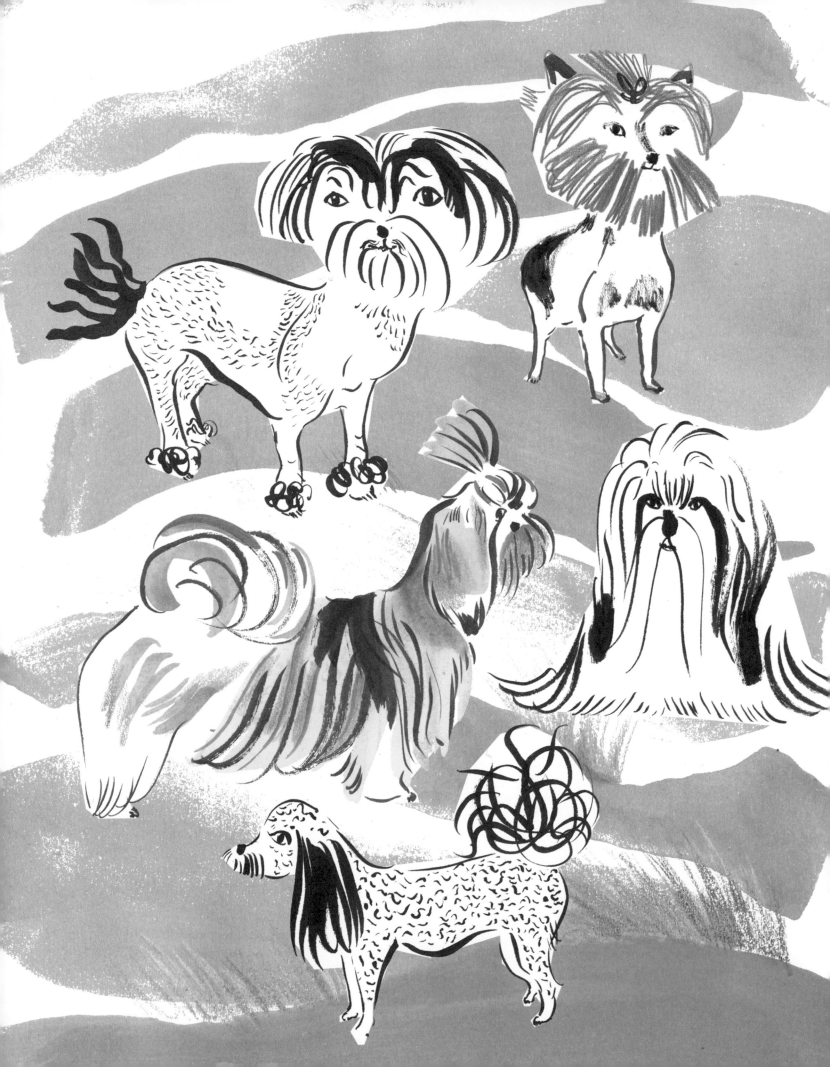

STAFFORDSHIRE BULL TERRIER

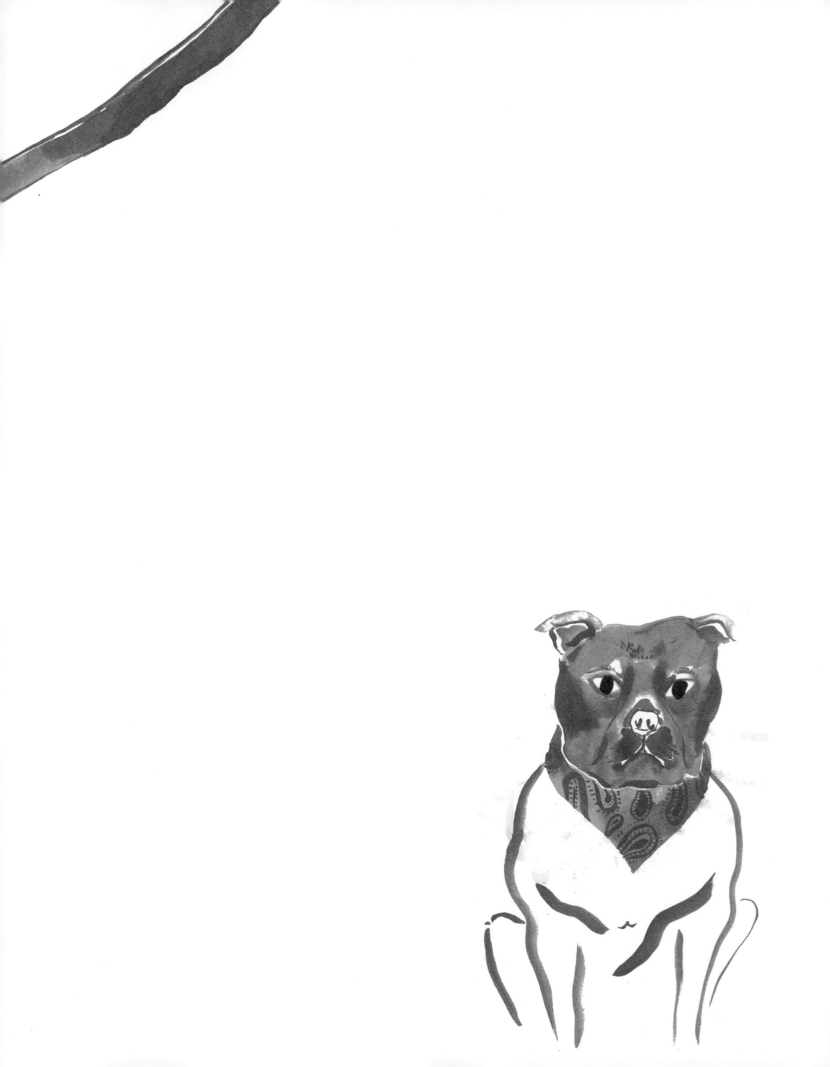

YORKSHIRE TERRIER

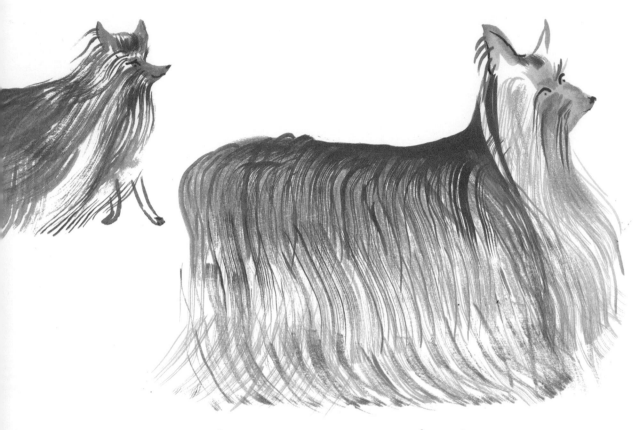

A feisty companion with a flowing coat.